Caravaggio

THE MASTER REVEALED

Sergio Benedetti

THE NATIONAL GALLERY OF IRELAND
1993

Published on the occasion of
an exhibition at The National Gallery of Ireland
18 November 1993 - 31 January 1993

Published by The National Gallery of Ireland

British Library Cataloguing in Publication Data available on request.

ISBN 0903162 687 Pbk

Edited by Fionnuala Croke
Designed and produced by Creative Inputs
Colour reproduction and printing by Nicholson & Bass

Cover: *The Taking of Christ* by Caravaggio (Detail)

CONTENTS

AUTHOR'S ACKNOWLEDGEMENTS

T hat morning in August, 1990, leaving the House of the Jesuit Fathers in Leeson Street, excited by what I thought I had just seen, I could hardly have imagined that just three years later, I would see my beliefs realised with an exhibition. In achieving this goal, the unprecedented munificence of Rev. Fr. Noel Barber and the Jesuit Community, Lower Leeson Street, Dublin, was fundamental, as was the support and constant encouragement of Raymond Keaveney, Director of the National Gallery, and the enthusiasm and perseverance of Fionnuala Croke, Curator (Exhibitions).

This project was planned and organised in a very modest period of time, and it would not have been possible without the cooperation of private lenders and of public institutions, in particular Lady Penelope and Sir Francis Ogilvy, the Rev. Fr. B. Jackson, the Borghese Gallery in Rome and the Chester Beatty Library, in Dublin. Equal gratitude is deserved by Neil MacGregor, and the staff of the National Gallery of London, for their unconditional assistance. I am obliged as well for the help received in the Scottish Record Office, in Edinburgh, and in the Archivio di Stato in Rome.

The opening of this exhibition takes place just a few days after the publication of the long awaited article on the discovery, and reflects the results and findings described therein. Throughout my research I discussed various questions associated with the painting with many friends and scholars; of these I owe a special debt to Sir Denis Mahon for his continuous assistance and innumerable suggestions.

Mina Gregori, Claudio Strinati, and Erich Schleier, were among the first to know of the painting and to confirm the attribution, while in the last two years the exchange of ideas with the indefatigable Francesca Cappelletti helped to clarify many of my doubts. In London, I received great help and patience from Caroline Elam and Duncan Bull and profited from discussions with Gabriele Finaldi, John Ingamells and Michael Helston. During my investigations in Scotland I saved invaluable time thanks to the suggestions offered to me by Mungo Campbell, Ian Gow, James Holloway, and Aidan Weston-Lewis.

The following people have in various ways assisted me with essential information and other kinds of help: Ferdinando Bologna, Peter Cherry, Luke Dodd, Burton B. Fredericksen, Federico Guidobaldi, Alessandra Guiglia Guidobaldi, Charles Horton, Nelly G. Lutskevitch, John Loughman, Marian Keyes, Brian McGinley, Sean Malone, Maurizio Marini, Patrizia Masini, Fausta Navarro, Kevin P. Nowlan, Philippe Pergola, Charles L. Spence, Luis de Moura Sobral, Laura Testa, Ilaria Toesca, Cinzia Vismara, and Lucy Wood.

To my colleagues at the National Gallery of Ireland, I wish to express my gratitude to Brian Kennedy for his skilful and discreet help and advice, and to Valerie Keogh, Adrian le Harivel, Marie McFeely, Maighread McParland and Andrew O'Connor for their assistance. Completing a catalogue with so many images, has required the involvement of our photographer Michael Olohan, and I am indebted to him. A significant note of appreciation is due to Bill Maxwell, Press Officer, for his invaluable professionalism.

My thanks also to Kathryn Carrigan for cleaning the Hamilton Nisbet frame. Finally I wish to acknowledge the expertise of Peter Monaghan and Michael Breen of Creative Inputs.

Sergio Benedetti

FOREWORD

In the history of European painting a small number of artists stand out as personalities of exceptional genius and influence. Among this select band, Michelangelo Merisi da Caravaggio must today rank as one of the most popular and admired. This was not always the case, however, and for a long period his paintings were considered of little importance. Indeed, so great was the fall in his popularity that works from his hand eventually lost their identity and were listed incorrectly in the inventories of their various owners. Such is the history of one of the master's most moving compositions, *The Taking of Christ*.

Painted for the Mattei family in 1602, this particular work had lost its identity by the late eighteenth century when it was listed in the family papers as the work of the Dutch artist Gerrit van Honthorst, who was known in Italy by the sobriquet Gherardo delle Notti. That a major work of such quality by an artist who in his lifetime attracted the distinguished patronage of cardinals and princes should lose its identity whilst still in the possession of the family who originally commissioned it in Rome seems astonishing. That this painting should turn up in the modest surrounds of a religious house in Dublin, following a protracted sojourn in Scotland, is even more extraordinary.

This intriguing mystery has at last been solved due to the keen eye and quick mind of Sergio Benedetti, a senior restorer at our Gallery, and an expert in seventeenth century Italian painting, who some years ago was invited to inspect a number of the paintings at 35 Lower Leeson Street, one of the houses of the Irish Jesuit community. Immediately recognising the picture as documenting a 'lost' composition by Caravaggio, which had been described by the artist's contemporaries Celio and Bellori and known from numerous versions, he suspected, given the painting's evident quality, that it could in fact be the original.

The research necessary to confirm Caravaggio's authorship has taken virtually three years dedicated work and involved the cooperation and assistance of numerous bodies and individuals. Most importantly it has involved the wholehearted support of the Irish Jesuit Fathers, who not only agreed to have the picture removed to the National Gallery for extensive examination, but who, in an act of unparalleled generosity, have subsequently agreed to place the work on indefinite loan for the enjoyment and enrichment of the Irish public and international visitors. In doing so they emulate the noble gesture of Dr. Lea-Wilson, the eminent Dublin pediatrician, who presented the work to the Jesuit house in Leeson Street some sixty years ago. The process of authentication benefitted enormously from the enthusiastic support of Sir Denis Mahon, who from the moment he was informed of the painting's discovery, offered his services to the Gallery. Neil MacGregor and his colleagues at the National Gallery in London have also lent assistance. Others, acknowledged elsewhere, have generously assisted with the investigations into the painting's origins and subsequent history. We gratefully acknowledge the financial support of Guinness & Mahon Ltd. in the mounting of the exhibition, which has been made possible through the cooperation of the lenders, both private and institutional.

Raymond Keaveney
Director

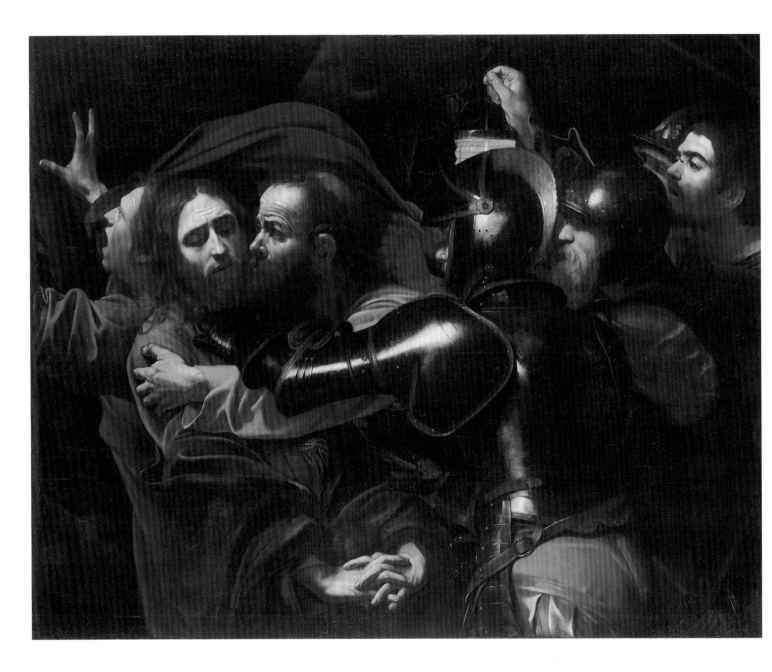

Plate 1.
Caravaggio, *The Taking of Christ*, National Gallery of Ireland, inv. no. 14,702

CARAVAGGIO AND THE MATTEI FAMILY

Michelangelo Merisi, better known as Caravaggio from his family's place of origin in Lombardy, was just twenty one years old when he reached Rome probably in the summer of 1592. The city, which had always been a destination for pilgrims from all over Europe, was by now also the goal for innumerable artists anxious to admire and study the remains of classical buildings and the artistic riches added to these through the munificence of successive popes. Some were drawn there by the high hope of finding success and fame, while others, more modestly, sought only a permanent occupation. Many, however, shared the view expressed in 1548 by the Portuguese artist and writer Francisco de Hollanda that 'Neither painters and sculptors nor architects can produce works of significance unless they make the journey to Rome', and the city that greeted Caravaggio at the end of the century certainly met with these expectations. Rome was enjoying a moment of particular splendour as the capital of a strengthening Catholicism reassured by the effects of the Tridentine counter-reforms, and inside the Curia, for the first time that century, the gradual increase of influence from France was balanced against the excessive political power of Spain.

With the papacy of Sixtus V (1585-90), the city had greatly changed its appearance. Many *rioni* or quarters had undergone large-scale urban renewal with many buildings being constructed, almost always of notable artistic prestige. Yet despite the apparently favourable conditions and the determination to assert himself immediately, Caravaggio's first years in Rome were very difficult. He was often forced to accept the hospitality of minor benefactors - like the Prelate Pandolfo Pucci who became famous as a result of offering only vegetable dishes to the young artist who dubbed him *'Monsignore Insalata'* - or of painters, little older than he but already established, who recognised his undoubted ability but who found it difficult to accept his sense of restless independence.

Towards the end of 1595, however, the wheel of fortune turned in his favour when he met Cardinal Francesco Maria Del Monte, the first of a series of eminent figures in Rome who would soon contend for his works. Del Monte, a man of refined culture and many interests, was immediately attracted by the novelty of this unknown artist's works which were selling for only a few *scudi* close to his residence, the Palazzo Madama, where he lived as a friend and representative of the Grand Duke of Tuscany. The Cardinal bought the *Cardsharps* (Kimbell Art Museum) *[Fig. 1]* and the *Fortune Teller* (Pinacoteca Capitolina) there, and decided to welcome Caravaggio into his own home, thus becoming his first important collector.

Without the daily preoccupation of supporting himself, and with the protection of the Cardinal who considered him his own discovery and excused his extravagances, Caravaggio came into contact with other influential members of Roman society, and obtained commissions for private works as well as his first important public undertakings.

Fig. 1.
Caravaggio,
The Cardsharps,
Kimbell Art
Museum,
Fort Worth.

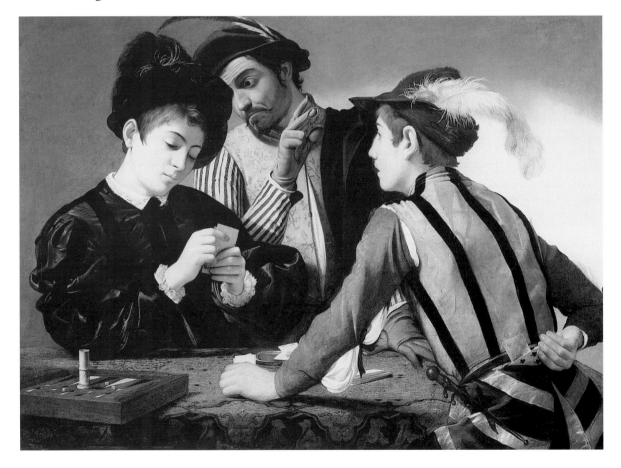

In this way, at the close of the century, he was given the commission of completing the painting of the Contarelli Chapel in San Luigi dei Francesi, the church situated next to Cardinal Del Monte's home. The commission was initially given to Giuseppe Cesari in 1591, better known as Cavalier d'Arpino who was to complete it within eighteen months, but as he had not progressed further than the frescoes in the vault after years of hesitation and postponement, it passed to Caravaggio. As stated in his contract, Caravaggio painted the works in oil: two large pictures, of *The Calling* and *The Martyrdom of St. Matthew [Fig. 2]* for the lateral walls, and two versions of *St. Matthew inspired by the Angel* for the altar.

Fig. 2.
Caravaggio, *The Martyrdom of St. Matthew*, detail, San Luigi dei Francesi.

Thanks to their innovative force and also to their accessibility, these works created a vivid sensation making the artist instantly famous. At the same time, in a highly competitive atmosphere such as existed in Rome, his success also fuelled the jealousy of other painters, a consequence not eased by Caravaggio's arrogance. Notwithstanding this, the requests for his work increased, including other public commissions such as the two canvases for the Cerasi Chapel in Santa Maria del Popolo, entrusted to him in the autumn of 1600.

From the moment he arrived in Rome, Caravaggio was continually experimenting in his paintings, always seeking new solutions of light and composition. During his stay with Cardinal Del Monte he demonstrated his ability to portray people and objects with a novel sense of realism, not the abstract and iconic realism perfected by northern european painters, but a lively and earthly realism, and rejecting any established categories among artists he declared that 'it required as much skill to paint a picture of flowers as one of figures'.

Towards the end of his time with Del Monte he achieved a new use of light through a continuous and constant process of stylistic evolution. Always directed from a source above the painting, this light seems to strike the figures in a piercing way which in some paintings reveals a more exalted intention, that of creating the illusion of divine intervention. To obtain this effect, Caravaggio obscures the background of the composition and through strong contrasts charges the emerging images with light, but only in those areas that he considers essential for the impact of the composition.

In a cultural environment which was saturated with a stale mannerism, Caravaggio was by now both celebrated and admired by those who recognised the revolutionary nature of his style, and to his great annoyance his work was imitated, even forged, by some opportunists. A little before June, 1601, and still on good terms, Caravaggio left the hospitality of Cardinal Del Monte and was received in the palace of another authorative figure in the Roman Curia, Cardinal Girolamo Mattei. Cardinal Mattei, Protector of Ireland and of the order of Observant Franciscans, also held the responsible position of *Prefetto della Sacra Congregazione del Concilio* for some time. The Mattei family claimed ancient origins, and having prospered economically throughout the sixteenth century they became one of the foremost families among the Roman aristocracy obtaining first the title of Marquis and a little later that of Duke. Their numerous houses and palaces were constructed above the ruins of the ancient *Teatro Balbo* and were eventually joined up to form a block, or *isola*, in the heavily populated Sant'Angelo quarter which lies between the Campidoglio and the river Tiber *[Fig. 3]*.

Fig. 3.
Maggi-Maupin-Losi,
Map of Rome (1625),
detail showing the
Mattei palaces.

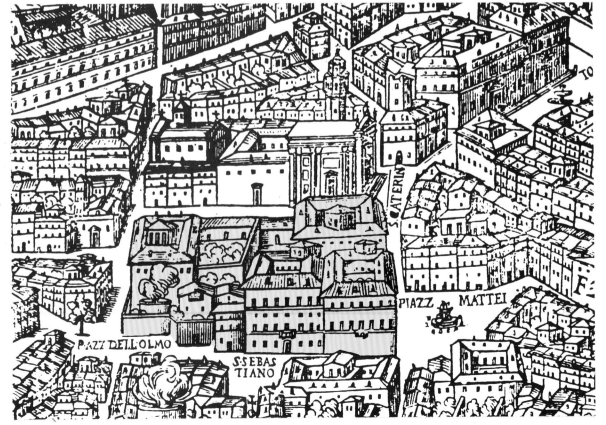

Although not the eldest, Cardinal Girolamo Mattei, owing to the dignity of his position, lived in the principal palace [*Fig. 4*], while his two brothers, Ciriaco, one year older, and Asdrubale, ten years younger [*Fig. 5*], lived in an adjacent house. In 1598, after demolishing several houses which he had inherited, Asdrubale had begun the construction of a new palace designed by the architect Carlo Maderno next to the church of Santa Caterina dei Funari. By means of good investments, inheritance and fortuitous marriages, both Ciriaco and Asdrubale had considerable property at their disposal comprising of feuds and estates. Moreover, like many representatives of the Roman nobility at the time, they were also great collectors of classical antiquities and paintings.

From the Mattei archives we now know which of Caravaggio's paintings were commissioned from these two brothers during the period he lived with the family. It is clear from the documents that Asdrubale Mattei owned, at least from 1603, a painting by Caravaggio of *St. Sebastian,* while Ciriaco Mattei owned three others.

For these three works, the detailed payments are known. The first was paid for at the beginning of January, 1602 and given the description '*Quadro di N.S. in*

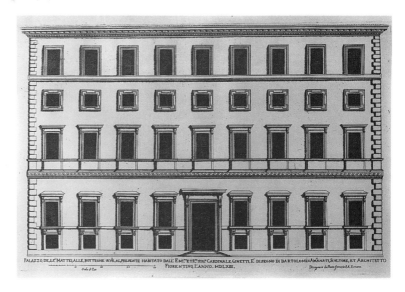

Fig. 4. Pietro Ferrerio, *Mattei-Caetani Palace, (circa 1655-70)*

Fig. 5. Unknown artist, *Portrait of Asdrubale Mattei (1556-1638),* Musée Conde, Chantilly.

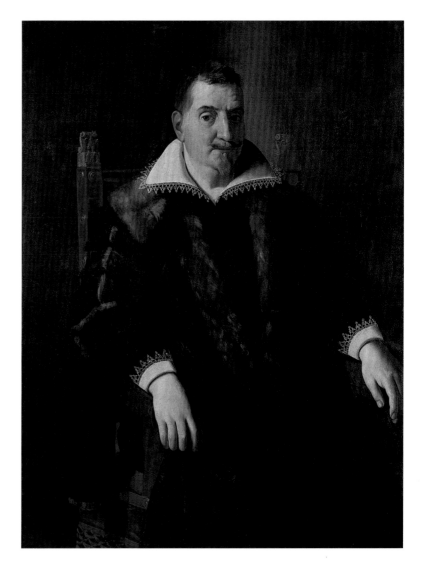

11

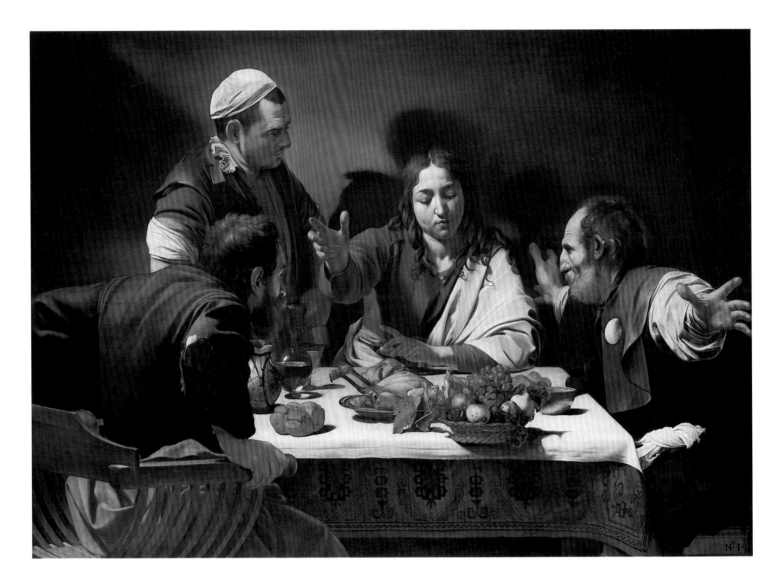

Plate 2.
Caravaggio, *The Supper at Emmaus,* National Gallery, London.

fractione panis' ('A painting of Our Lord breaking bread'), it undoubtedly refers to the *Supper at Emmaus* that is today in the National Gallery, London *[Plate 2]*. Following this, Caravaggio received two further payments from Ciriaco Mattei, in July and December of 1602, for another painting which has been identified with the *St. John the Baptist* in the Pinacoteca Capitolina *[Plate 3]*. The last picture commissioned by Ciriaco was a *Taking of Christ* for which Caravaggio was paid 125 *scudi* on the 2nd January, 1603 *[Fig. 6]*, and which is now in the care of the National Gallery of Ireland *[Plate 1]*.

Although the dates of payment are known for these three paintings, it is not easy to establish precisely how long it took Caravaggio to execute them. By observing his technique, we can be certain that he painted instantaneously. He did not use preparatory sketches - unless they were requested - and with a few strokes of the brush he unhesitatingly painted a composition which was already completely realised in his mind. Finally, when he was almost finished, he made any modifications he considered necessary, which in most cases were minimal.

Fig. 6. Document of payment to Caravaggio for the *Taking of Christ*, Antici-Mattei Archives, Recanati.

With his growing popularity the requests for new works in these years increased. Although he painted rapidly, it does not seem that he was constantly assiduous, and according to Karel Van Mander, 'after a fortnight's work he will swagger about for a month or two with his sword at his side and with a servant following him, from one ball-court to the next, ever ready to engage in a fight or argument, with the result that it is most awkward to get along with him'.

The type of hospitality offered to him by the Mattei family, however, did not prevent him from taking on other commissions. On the contrary, it was during this period that he completed the already mentioned canvases for the Cerasi Chapel in Santa Maria del Popolo (10th November, 1601) and the two versions of the *St. Matthew* for the altar of

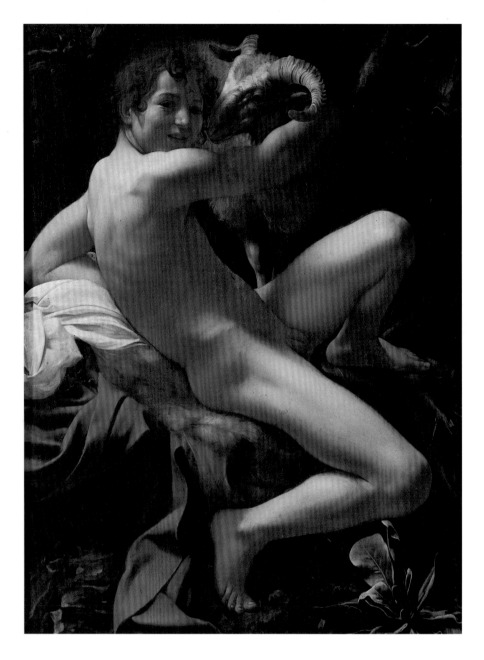

Plate 3.
Caravaggio, *St. John the Baptist,* Pinacoteca Capitolina, Rome.

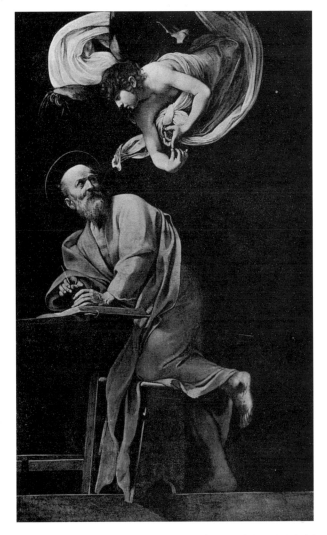

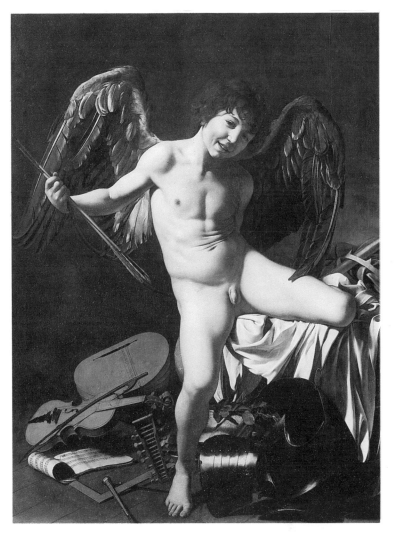

Fig. 7. Caravaggio, *St. Matthew and the Angel*, San Luigi dei Francesi, Rome.

Fig. 8. Caravaggio, *Victorious Earthly Love*, Gemäldegalerie SMPK, Berin-Dahlem.

the Contarelli Chapel (the second of which was paid for on 22nd September, 1602) *[Fig. 7]*. It is also more than probable that at the same time he painted the *Deposition* for Santa Maria in Vallicella (now in the Pinacoteca Vaticana) and the *Death of the Virgin* for Santa Maria della Scala (Louvre, Paris). There are, therefore, a considerable number of pictures which Caravaggio, given the circumstances, may have in large part painted in the palace of his temporary patron. It was also at this time that he executed two other important works for the Marchese Giustiniani, the *Victorious Earthly Love* now in Berlin (before August, 1602) *[Fig. 8]* and the *Incredulity of St. Thomas [Plate 4]* a little later. The second of these, today at Potsdam (Sanssouci Bildergalerie), was also, in the present

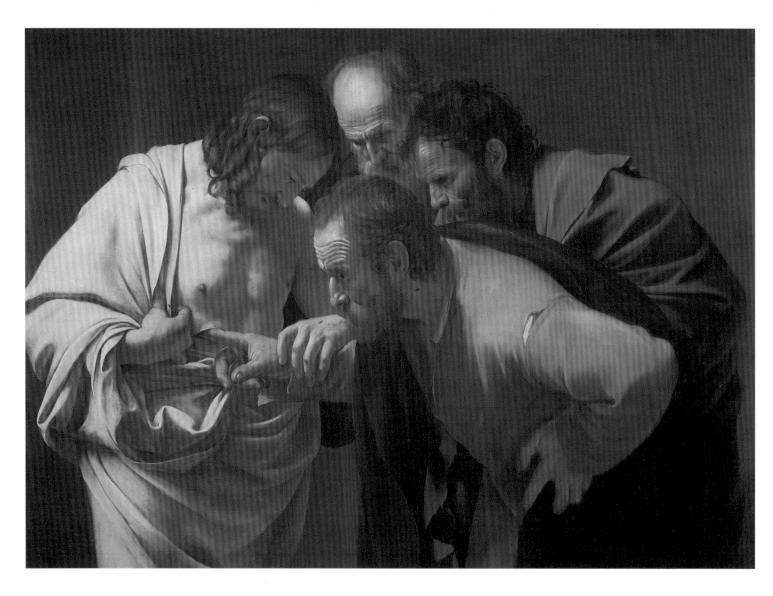

Plate 4.
Caravaggio, *The Incredulity of St. Thomas*, Sanssouci Bildergalerie, Potsdam.

writer's opinion, completed in Cardinal Mattei's palace. This would provide a logical explanation for Giovanni Baglione's assertion in his biography of the artist, (certainly based on incorrect information), that even this painting had been ordered by Ciriaco Mattei, maliciously adding 'Thus Caravaggio relieved this gentleman of many hundreds of scudi'.

Given his personality, Cardinal Girolamo Mattei should not be seen as simply Caravaggio's protector, but also as a source of influence and inspiration above all in the interpretation of the subject matter of some paintings. This pious and reserved man, noted for his dedication to the promulgation of the decrees of the Council of Trent, had extremely close ties with the most strict of the Franciscan Orders, the Observants. In their principal church, Santa Maria in Aracoeli, there were two chapels belonging to the Mattei family, and it is in the chapel dedicated to St. Matthew, patron saint of the family, that the Cardinal was buried in December, 1603 having left instructions that no pomp or images of him should be celebrated as a demonstration of his austerity *[Fig. 9]*. This modesty is revealed also in an inventory of his belongings which indicates that he did not personally possess more than sixteen paintings, barely sufficient to decorate the main rooms in his vast palace.

It is not surprising, therefore, that despite having Caravaggio in his house for about two years, Cardinal Girolamo does not appear to have been served by him and that he left it to Ciriaco above all, and to Asdrubale to order paintings from the artist. At the same time, in the selection of the themes of at least two of these, the *Supper at Emmaus* and the *Taking of Christ*, the Cardinal must have played an influential role. If this is the case, it would explain the artist's borrowing for these works from the *Meditationes vitae Christi*. This, a text written in the fourteenth century by an anonymous Tuscan Franciscan was, at the time of Caravaggio, believed to be the work of St. Bonaventure and was particularly dear to the Capuchin Friars for its considerable spiritual content. In the *Supper at Emmaus*, although the doctrinal representation of the divine presence in the Eucharist, one of the tenets of the Council of Trent (Transubstantiation), is evident, the similarities with the Pseudo-Bonaventure citation of the episode is more perceptive. Caravaggio's portrayal of the manifest poverty of the two surprised disciples in the scene, one of whom shows a wide tear on the elbow of his coat, was considered 'vulgar' by the majority of his later critics. What these, although eminent, connoisseurs did not realise was that the artist had just visually interpreted the spirit of his written source, which emphatically exalted the goodness of Christ in making himself available first to the poorest.

An equally important religious message transpires from the *Taking of Christ*. Here the silent and submissive acceptance of Jesus with his hands, so prominently clasped in a gesture of faith, reveals a number of moral concepts – Abnegation, Obedience and Sacrifice – which are essential elements of the Franciscan Ethic.

For the two remaining works the explanation seems to be simpler. The *St. John the Baptist* was certainly requested by Ciriaco Mattei in honour of his eldest son who carried the same name as the saint. In this picture the original source for the elegant but unusual pose of the young precursor, was evidently a Sistine nude by Michelangelo, but it was also suggested to Caravaggio by the bronze youths made by Taddeo Landini for the *Turtle Fountain*. This monument which is located on the west front of the Mattei Palaces [Fig.3], was one of the most celebrated artistic creations of the late Roman Renaissance, and was also an ornament to this family and its refined taste. The *St Sebastian*, as far as we know was the only painting by Caravaggio owned by Asdrubale Mattei. This picture, not yet traced, perhaps owed its choice of subject matter to the small church dedicated to the saint which at the time was so close to their houses as to be called *San Sebastianello "alli Mattei"*.

The time Caravaggio spent with the Mattei, arguably about two years, coincided with the most successful phase of his painting in Rome, and certainly the happiest period of his short life. From the uncertainties he experienced with the first versions of some of his public commissions which were laboured and still mannered, he progressively evolved a compositional synthesis in which human drama predominates, resulting ultimately in images of classical monumentality. Not everyone was prepared to accept or understand his great innovations, however, and as a result other painters, whom Caravaggio himself considered unworthy, were preferred to him and received important commissions from religious orders. Equally, the rejection of altarpieces which he had already delivered and could not remedy, as had happened in the past, marked him deeply.

From the summer of 1603 onwards, he was the protagonist in a sequence of events, more as a consequence of his intemperate behaviour than for his artistic activity. Arrested several times, he was repeatedly found guilty and imprisoned, sometimes being saved by the intercession of important protectors, at other times because he reached a compromise with the injured party. In every case, however, he was hindered by his obstinate arrogance. Once, when interrogated while bedridden with sword wounds, he replied, 'I wounded myself with my sword in falling on the streets. I don't know where it happened, and no one was present'.

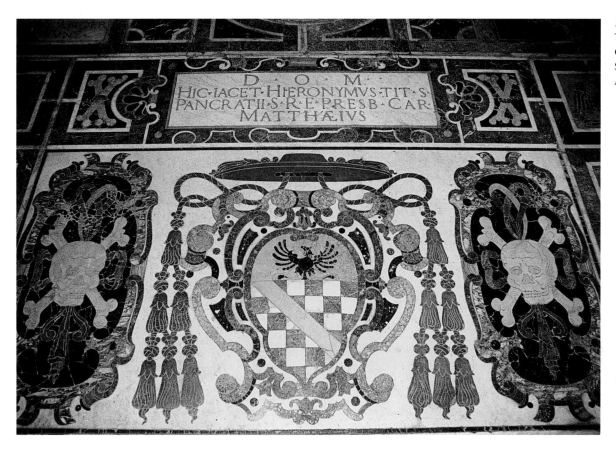

Fig. 9.
Tomb of Cardinal
Girolamo Mattei,
Santa Maria in
Aracoeli, Rome.

Then, on the evening of Sunday, 28th May, 1606 something irreparable and perhaps inevitable occurred. During a game of *pallacorda* (a form of tennis) in which he was playing, a brawl started over a question of rules and money and Caravaggio killed one of his antagonists. He fled Rome taking refuge with a branch of the Colonna family (who had been protectors for a long time) thus beginning a long and painful journey which brought him first to Naples, then to Malta, finally to Sicily, and then back to Naples, always hoping for a papal pardon and a reprieve of his banishment. Believing it was about to be granted he embarked on a ship to Rome, but a twist of fate prevented him from reaching his destination and he found himself alone, without his possessions and feverish on the Tuscan coast of Port'Ercole where he died on 18th June, 1610 aged only thirty-nine years. The news of his death arrived in Rome several days later, and a curt notice, addressed to the Duke of Urbino reported: "Word has been received of the death of Michelangelo da Caravaggio, the famous painter, excellent in the handling of colour and painting from life, following an illness in Port' Ecole."

THE BREAK-UP OF ROMAN COLLECTIONS IN THE EIGHTEENTH CENTURY
AND THE FATE OF AN UNRECOGNISED CARAVAGGIO

Around the middle of the eighteenth century, the long and grandiose era of baroque art in Rome had inevitably come to an end. In painting, artists such as Corrado Giaquinto or Sebastiano Conca no longer responded to local taste, and the still active interest in the classicism of Raphael and the Carracci found new promoters in the works of Pompeo Batoni and the Bohemian Anton Raphael Mengs. The rediscovery of the cities of Herculaneum, Paestum and Pompeii had a determining effect in the growth of this new tendency which came to be known as Neoclassicism. The illustrated publication of the recovered antiquities from these sites offered a catalogue of new examples which could be imitated. At this time too, Johann Joachim Winckelmann provided the first systematic text on the history of antique art. Equally important was the diffusion of the new ideas of Piranesi and Robert Adam and the presence in Rome of young, foreign artists like the students *(pensionnaires)* of the French Academy in Palazzo Mancini who by studying and reinventing *l'antico* aroused an interest for all things classical.

In a time of cultural transition, therefore, Rome succeeded once again in offering a new artistic orientation and, thanks to her history and monuments, in attracting groups of travellers from every corner of Europe who came to be known as Grand Tourists. The ungenerous words of Charles De Brosses about the Romans, '... a population, a quarter of which is formed of priests, a quarter of statues, a quarter of people who hardly ever work, and the last quarter of people who do absolutely nothing' reflect perhaps a society with a precarious economy and lacking in modern industry but at the same time capable of intellectual regeneration by exploiting the energies of her new visitors.

Of the foreign colonies resident in Rome the largest and wealthiest and therefore the most evident, was the British community (which at the time also included Irish visitors).

Largely male, this colony was concentrated in the streets around the Piazza di Spagna, in the area popularly called the *'Ghetto degli Inglesi'*. In one of their favourite meeting spots, the *'Caffè degli Inglesi'*, surrounded by Egyptian decorations created by Piranesi in an atmosphere thick with tobacco smoke, the *Milordi* read and discussed the latest notices which had arrived from London and exchanged notes and information on places to visit. The choice was endless and to accompany them if necessary there were guides, better known for their eloquence as *ciceroni,* who led them to churches, palaces, towns and ruins, and influenced their taste and interests.

Among the most appreciated of these *ciceroni* was the Scottish architect James Byres, a member of the Accademia di San Luca, who held a course lasting around six weeks at a cost of 20 *sequins* (£10). A day in his company was always conducted in a carriage, lasted between four and five hours, and on occasion he would even propose, and mediate in, the acquisition of antiquities and *objets d'art*. The assistance of antiquarians such as Byres and their network of contacts was of inestimable value. As the patrons of numerous artists, they promoted their works among the rich tourists, inviting these visitors to frequent the studios which in some cases were truly intellectual meeting places. In Angelica Kauffman's welcoming home in the via Sistina one could meet artists like Mengs or his pupil von Maron, engravers of the calibre of Morghen or Volpato, or the very influential Roman born dealer, Thomas Jenkins. Without doubt, however, the studio that was a 'must' for every true gentleman was that of Pompeo Batoni. There, one could admire his latest creations and at the same time be entertained by the well known musical ability of his daughters. Batoni, undoubtedly an artist of great talent, moreover knew just how to respond to the desires and taste of his clients who, largely British, preferred him to his less gifted rival Mengs.

These were the pastimes and pleasures of the largest foreign community in the Papal City, but the circumstances for Rome's own citizens were very different. The city at the time numbered 150,000 inhabitants, for the most part crowded into the central quarters. Factories were few and of little importance, and, therefore, the principal occupations were the traditional ones of services and small craftsmen who set up in modest workshops sometimes located in the ground floor of the decaying palaces of the nobility. The almost total disinterest of the local aristocracy in the citizens' activities meant that an entrepreneurial class was practically non-existent. The nobility, almost all owners of large estates and responsible for the agricultural production for the entire Papal State, were accustomed to an antiquated, patriarchal management of their land and few made any

attempt to improve conditions or to adapt to modern developments. Clement XIII's apostolic confessor commented in a letter that *'Questi signori principi tutti fanno andare il loro terrini a prato e così provedono più le bestie che gl'uomeni'* ('These lords are all allowing their land to go to seed and so they are providing more for animals than for men'). When, from 1763 to 1767, a serious drought in the surrounding countryside resulted in meagre crops of poor quality, the lack of appropriate emergency measures, made more acute by the carelessness of the papal administration, dramatically revealed the inefficiency of the entire system.

Naturally, the first to suffer the effects were the peasants who, starved and without resource, poured into the city swelling the numbers of the poor and beggars. After them, it was the turn of the Roman patriciate whose members, lacking in ideas, were incapable of finding viable economic solutions and, seeing their principle source of income decrease day by day, turned to the sale of the art treasures accumulated by their ancestors as the only alternative open to them. It is true that this dispersion had already started some time earlier but there is no doubt that the crisis described above accelerated matters. To prevent the export of important works, successive popes had personally acquired collections or part of them, assembling them primarily in the new Museo Pio-Clementino. This is what happened to many of the classical sculptures from the Mattei family villa on the Celio hill which the last Duke Giuseppe was obliged to sell to Pope Clement XIV in 1770 for the *'critiche circostanze ed incomoda situazione, in cui trovasi presentemente lo stato economico della sua casa'* ('critical circumstances and uncomfortable situation in which the economic state of his home is at present'). Another solution adopted by the papal government was the institution of a controlling office, called the *Camerlengato* run by a Cardinal who had power over affairs relating to *objets d'art* and antiquities, assisted by a *Commissario* and two *Assessori* (one responsible for painting and the other for sculpture). Nevertheless, many art works left Rome illegally, leading to the formation of many major European collections.

Among the most active in the sale of art works were the foreign antiquarians who were resident in Rome for some time and were ready to satisfy the increasing desires and ambitions of their fellow citizens, the Grand Tourists, to enrich their country houses. Among these several were Scottish, such as the Abbé Peter Grant or Andrew Lumsden, secretary to the Old Pretender, and were well known Jacobites, which facilitated access to the ecclesiastical hierarchy including the Pope. Others, instead, were talented artists like Colin Morison or the landscape painter Jacob More, or Gavin Hamilton who was

also an able archaeologist and neoclassical theorist. The best known of all, however, was the already mentioned James Byres, admired for his taste and his experience even by Edward Gibbon whom he served as a guide in 1764.

Byres left Rome in 1790 to return to his estates in Aberdeenshire, but not before entrusting his business to his nephew Patrick Moir who had assisted him for many years. Moir continued the profitable activity as *cicerone,* dealer and financier (he was referred to as 'the English Banker in Rome'), remaining in the city even during the difficult years of the French occupation. In 1798, two hundred and seventy one years after the devastations carried out by the troops of Charles V, Rome once more suffered from an armed invasion. Two years earlier, commanding the republican army, Napoleon had entered Italy and invading the Papal State had imposed severe sanctions among which was the seizing of one hundred works of art, selected by his *commissaires,* as war indemnity. This abuse, which in practice legalised the victor's pillage, had already been established in Paris in 1794 with the aim of supplying the Louvre which was being transformed into a public museum. When General Berthier entered Rome on 10th February, 1798 the Roman aristocracy, already in economic decline, were thrown into consternation as they waited to be deprived of their property. This would soon happen, but not directly affecting art works as they feared. In fact, the French military command had established that private collections were untouchable, even if there were exceptions to this rule. Instead they imposed on the new Roman administration an immediate payment of three million *scudi* and of another six hundred thousand within three months for the maintenance of their army. The consequence was the institution of a tax of 3% on the value of private funds and 5% on those of the ecclesiastics. Finding such an amount must have been difficult for many families and certainly created a favourable climate for speculators. On the other hand, the easy revenue from the sale of paintings and sculptures was interrupted by the disappearance of the principal buyers, the British tourists. Those who remained for love of the city saw their property completely confiscated by the predatory French administration. Those who had left suffered from nostalgia as is apparent in the words of the Irish painter Hugh Douglas Hamilton, writing to Canova: 'I wish I were in Rome where I could see your work ... living in Ireland is almost like being in exile for anyone who truly loves art'. Finally, in the summer of 1800 the papal government was re-established and with the arrival of the newly elected Pope, Pio VII, the situation slowly returned to normal and with normality the foreign visitors also returned; for them, despite the war and the precarious truces, the attraction of Rome never ceased.

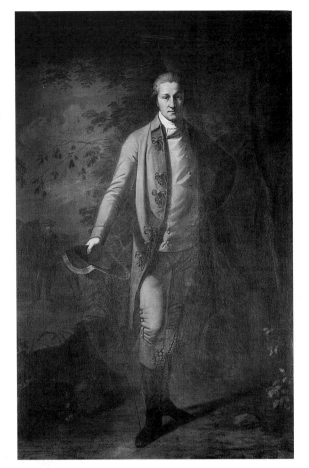

PALAZZO DELL'ILL.^{MO} ET ECC.^{MO} SIG. DVCA GIROLAMO MATTEI ET FACCIATA VERSO S.^{TA} CATERINA DE FVNARI NEL RIONE DI S. ANGE- LO ARCHITETTVRA DI CARLO MADERNI.

Among the first to arrive was William Hamilton Nisbet *[Fig. 10]*, a Scottish gentleman who was several times a member of Parliament and who had probably already visited Rome on many occasions. He was certainly there in 1772, aged twenty five, when in the company of Lord Findlater and another visitor in the Borghese palace, he met the Scotsman Patrick Home who recorded the meeting in his travel journal. Apart from the vast properties he already owned - such as the ancestral home of Archerfield in Dirleton which was restructured to his orders by Robert Adam in 1790 - Nisbet had inherited Biel house near Stenton a few years earlier after the death of his mother, at which time he added her name to his own. The sole heir of a considerable fortune he thus became one of the wealthiest lairds in Scotland and on his return to Rome he lost no time in seeking out old master paintings for his large country houses.

He was assisted in this enterprise by Carlo Labruzzi, an artist who was frequently in contact with, and at the service of, other British tourists. Labruzzi, knowing the quality of the Mattei collection and their willingness to sell because of their economic difficulties, introduced Hamilton Nisbet to the head of that family Duke Giuseppe. Although works had already been relinquished, the Mattei still held a substantial artistic

heritage and, in particular, the picture gallery which had remained practically intact since the time of the Marquis Asdrubale. Their palace beside Santa Caterina dei Funari, called Giove *[Fig. 11]*, from the name of their principal fief, was one of the most celebrated in Roman guide books because apart from a vast collection of antiques it contained oil paintings and frescoes by the most important masters of the seventeenth century. Some years earlier many of these paintings had undergone a series of reattributions by some *cognoscente*, perhaps called in to value the collection for a possible sale or perhaps only to draw up a new city guide. Among these, the *Taking of Christ,* the only painting by Caravaggio still in the family's possession, was incorrectly attributed to his Dutch follower Gerrit van Honthorst who was recorded with his Italian sobriquet 'Gherardo delle Notti', and by a banal error of transcription transformed to 'Gherardo della Notte', a mistake which was perpetuated in every successive document.

William Hamilton Nisbet's interest in the Mattei paintings achieved a satisfactory conclusion on 27th January, 1802, when he reached an agreement for the acquisition of six oil paintings *'di autori diversi'* ('by different artists') owned by Duke Giuseppe Mattei, for a total cost of 2300 *scudi romani [Fig. 12].*

Fig. 12. Receipt of payment, Ogilvy manuscripts, Scottish Record Office, Edinburgh

Fig. 13. Certificate of sale, Ogilvy manuscripts, SRO, Edinburgh

On 1st February a new document was signed attesting to the transaction in which not only the subjects of the paintings were described but also their presumed authors *[Fig. 13]*. The first picture mentioned in this list was *l'Imprigionamento del N.S. di Gherardo della Notte [sic]'* ('The Imprisonment of Our Lord by Gherardo della Notte').

Given the unstable relations with France, Hamilton Nisbet must have been very anxious to send the paintings home as soon as possible because on 8th February he made a request to the office of the *Camerlengato* for permission to export the six paintings, which was granted just two days later. The petition was presented by Byres' nephew, Patrick Moir, who we know remained in Rome until 1805. Evidently expert in this procedure, Moir declared a significantly reduced value, which was a quarter of what was actually paid, to ensure approbation *[Fig. 14]*.

After this, the consigning of the paintings to Scotland could not have been delayed much and so Hamilton Nisbet, although unaware of the fact, had succeeded in obtaining a work by Caravaggio, as well as five other pictures, some the works of his followers. This gentleman's propensity for a certain type of picture with strong colours and strong contrasts is confirmed by his subsequent Roman acquisition, a copy of Caravaggio's *Cardsharps*, taken from the original which at that time was still in the Barberini collection. For the Mattei, however, it seems that the sale of their best paintings failed to resolve the problems which afflicted them. In fact, in the same year Duke Giuseppe decided to sell the renowned villa on the Celio and just a few years later other sculptures and paintings that went on to form part of the collection of Napoleon's

uncle, Cardinal Fesch. In 1801, with the death of Filippo, the Duke's only son, the direct line of descent of the family was extinguished and the title passed, by the marriage of the last heir Marianna Mattei with Carlo Teodoro Antici, to their heirs who assumed also the latter surname becoming the Dukes Antici-Mattei.

On his return to Scotland, William Hamilton Nisbet dedicated much of his time to remodernising Biel House, the country home inherited from his mother, following the plans of the architect William Atkinson. The paintings from the Mattei palace were accommodated here with new frames in the neoclassical style, retaining on the labels the names of the authors indicated at the time of their purchase. The label for the *Taking of Christ*, therefore, maintained the name of Honthorst together with the ambiguous sobriquet 'Gherardo della Notte' repeating the error started many years earlier by the anonymous archivist of the Mattei *[Fig. 15]*. The unrecognised Caravaggio remained with the other paintings in Biel House until 1921 when, following the death of Constance Nisbet Hamilton Ogilvy the last direct descendant of that family, it was unsuccessfully auctioned by Dowell's in Edinburgh and consequently withdrawn. Only

Fig. 15.
Label from the
Taking of Christ

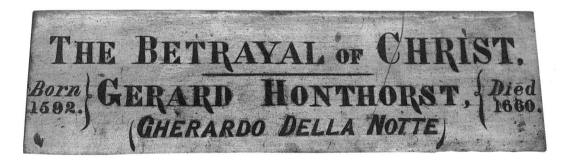

some time later was the picture finally purchased by Dr. Marie Lea-Wilson, a noted pediatrician in Dublin who was widowed at a young age when her husband was tragically killed. At the beginning of the 1930s, she presented it to the Jesuit Fathers of the house of St. Ignatius in Dublin still bearing the label with Gerrit van Honthorst's name. The *Taking of Christ* was carefully preserved in this house until recently when it was finally recognised and restored to Caravaggio, and with an unequalled act of generosity, the Father Superior, Noel Barber SJ and the community in Leeson Street, placed it in the care of the National Gallery of Ireland on indefinite loan.

THE TAKING OF CHRIST

When Jesus had spoken these words, he went forth with the disciples across the Kidron valley, where there was a garden, which he and his disciples entered. Now Judas, who betrayed him, also knew the place; for Jesus often met there with his disciples. So Judas, procuring a band of soldiers and some officers from the chief priests and the Pharisees, went there with lanterns and torches and weapons. Then Jesus, knowing all that was to befall him, came forward and said to them, 'Whom do you seek?' They answered him, 'Jesus of Nazareth.' Judas, who betrayed him, was standing with them. John 18: 1-6

Now the betrayer had given them a sign, saying, 'The one I shall kiss is the man; seize him and lead him away safely.' And when he came he went up to him at once, and said, 'Master!' And he kissed him. And they laid hands on him and seized him. Mark 14: 45-47

In his interpretation of this scene from Christ's Passion *[Plate 1]*, Caravaggio chose a horizontal format frequently used in the north of Italy by painters like Lorenzo Lotto whom Caravaggio clearly admired *[Fig. 16]*. Caravaggio used this format on a number of occasions and although the figures are scarcely more than half-length they are depicted powerfully and dramatically. Christ, the leading actor in this drama, is pushed sideways by his assailants and by Judas who has leaned forward to kiss him in his act of treachery. The juxtaposition of their two heads, framed by the arc of the dark red cloth, creates a strangely emotive focal point for the composition containing within it the contrasting expressions of the submissive Christ and his brutal betrayer.

In the painting Caravaggio has taken little account of the various earlier iconographical solutions to the story of the arrest of Christ; instead his is a strongly dramatic vision that contrasts Christ's calm acceptance of his fate (as stressed in the version of the story given in St. John's gospel) with the aggressive violence of his persecutors. Christ's hands, so prominently placed at the bottom of the picture's central axis, are clasped in a gesture of faith. As we have already seen, this interpretation of the subject was probably influenced by Cardinal Girolamo Mattei in whose household the painter was living at precisely this time.

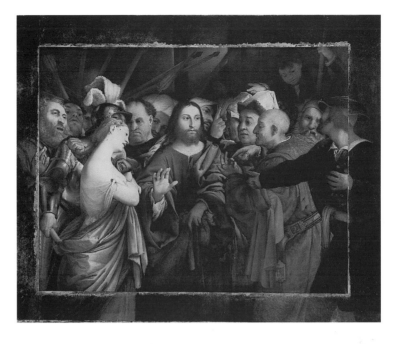

Fig 16.
Lorenzo Lotto,
*Christ and the
Woman Taken in
Adultery*,
Musée du Louvre,
Paris

Like many other artists Caravaggio took suggestions also from some early and contemporary prints the circulation of which was widespread not only among collectors. In the *Taking of Christ*, a detail from Dürer's woodcut on the same subject gave the artist the idea for the central group of Jesus, Judas, and the Roman guard *[fig.17]*.

Emotional contrasts are again expressed in the attitudes of the figures at the extremities of the scene. Terrorized, the young man fleeing on the left cries aloud; as mentioned in St. Luke's account, his red cloak has been seized by the bearded soldier. This ability to create an almost audible sense of drama in

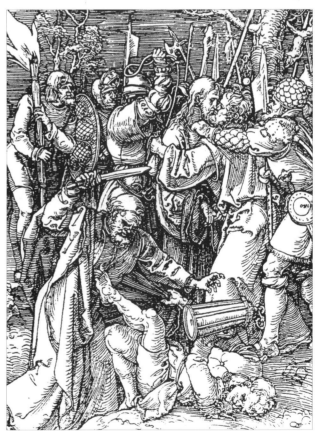

Fig 17.
Albrecht Dürer,
*The Taking of
Christ*, from the
small woodcut
Passion, 1509.

Fig. 18.
Detail of *Plate 1*

Fig. 19.
Moretto, *Death of
St. Peter Martyr*,
detail, Pinacoteca
Ambrosiana, Milan

Fig. 20.
Roman sarcophagus
(detail), 3rd century,
Vatican Museums

Fig. 18. Fig. 19. Fig. 20.

his paintings is a feature of Caravaggio's art which has been repeatedly commented on by writers in the past. The canonical colour of the disciple's clothes does not leave any doubt about his identification; he is St John the Evangelist, the most beloved of Jesus' followers. Traditionally this saint has been shown running away naked in the distance, but Caravaggio's approach is more subtle. He has utilised this moment in the gospel account to create an incident which ultimately links the composition into a unified whole from the action of the soldier, whose hands occupy centre stage, past and beyond the climactic moment of the traitor's kiss. The consternation in his pose and the decisive scission of the figure at the margin of the canvas *[Fig. 18]* bear more than a passing similarity to the young Dominican in Moretto's *Death of St. Peter Martyr,* painted for the church of Ss. Stefano e Domenico in Bergamo and now in the Pinacoteca Ambrosiana *[Fig. 19].* It seems reasonable to presume that Caravaggio may have noted this example on a visit to Bergamo, a reminder that throughout his life he drew on memories of works that he had seen during his youth.

As with many other artists, classical sculpture became another important source of inspiration in this phase of his art, and it is no coincidence that the Mattei were among the most avid collectors of antiquities in the Rome of their day. The sculptured images of Roman sarcophagi and in particular the frequently represented excited dancing Maenads of the so-called 'Dionysiac' type *[Fig. 20]* must have provided another stimulus for the fleeing disciple.

The armour of the soldier in the foreground is a type used by cavaliers, and very closely recalls examples produced in Lombardy, in the last quarter of the sixteenth century *[Fig. 21]*. In addition to these influences from earlier art Caravaggio certainly used live models and the face of the bearded soldier with the heavy, rusted helmet on the right reappears frequently in works of this period *[Plates 2 and 4]*. For the figure of Judas, and for the intensely expressive Christ he used new models instead, both of necessity powerfully and precisely characterised *[Fig. 22]*. A third soldier can only be glimpsed at the back of the group to the right. He is obscured by the man carrying the lantern. This man, evidently following the guards, is not wearing armour but is dressed in a blue and red cloak suggesting that he may be a priest of the temple. It has been proposed that his features are those of Caravaggio himself *[Fig. 23]* who since the discovery of the documents recording the payment for the painting we know was just thirty-one years old, at the end of 1602. His lantern, deceptively, has a purely visual role as it does not throw light on the scene; the true light source, creating the strong contrasts of light and shade, is placed high on the left beyond the view of the spectator.

Fig. 21.
Armour, Lombard workshop, c.1570/80, Museo Diocesano, Mantua

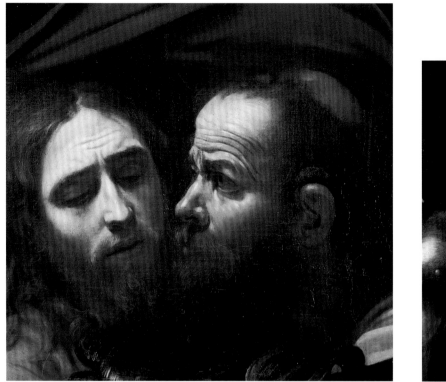

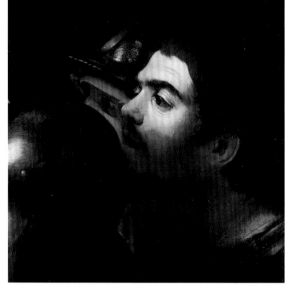

Fig. 22. Detail of *Plate 1* *Fig. 23.* Detail of *Plate 1*

Caravaggio's paintings of this period had a fundamental impact on those painters who became his followers. However, with respect to the *Taking of Christ*, we must first consider just how accessible the painting was. Of the early writers on art, only Gaspare Celio and Giovanni Pietro Bellori record the picture. Celio saw it while working in the old Mattei palace where the *Taking of Christ* was still located. Bellori, instead, saw it after the painting had been transferred to the new palace built by Asdrubale Mattei. Bartolomeo Manfredi, one of Caravaggio's earliest followers, appears to have been one of the few artists who knew the picture at first hand. Its influence is evident in a canvas of the same subject painted by Manfredi, once in the collection of the Archduke Leopold Wilhelm in Antwerp and known now from an engraving *[Fig. 24]*. In general, however, it seems that the Mattei collection was rarely open to artists and connoisseurs during the seventeenth century.

Many more artists would have known the *Taking of Christ* through the extensive number of copies which, probably from the second and third decades of the century, were probably circulating even outside Rome. An impressive amount of these copies exist today although almost all are of very limited quality. The only one of some significance is the example in the Museum of Eastern and Western Art in Odessa *[Fig. 25]*, which until recently was considered by some art historians to be the original. The

Odessa painting is undoubtedly very accurately rendered and leads one to surmise that it was copied directly from the master's work. In that case, it could be the recorded copy ordered by Asdruable Mattei in 1626 from the little known painter Giovanni di Attilio who was paid just twelve Roman *scudi* for the work. However convincing the provenance of the Dublin *Taking of Christ* is, therefore, it is the superior quality and masterful handling that ultimately impresses the viewer, and leaves little doubt that it must be the original.

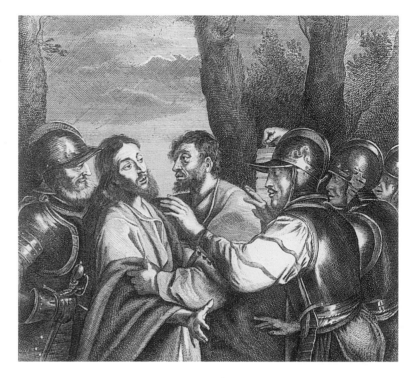

Fig. 24. After Bartolomeo Manfredi, *The Taking of Christ,* from David Teniers's *Theatrum Pictorium*

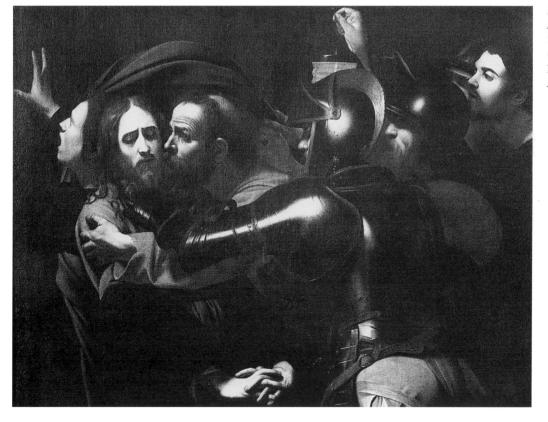

Fig. 25. After Caravaggio, *The Taking of Christ,* Museum of Eastern and Western Art, Odessa

A NOTE ON TECHNIQUE AND RESTORATION

Following its cleaning, several modifications or *pentimenti* made by the artist have come to light. Beginning with the soldier at the centre of the composition, some changes are evident on the belt of his sword which was later enlarged at the point where it is inserted into the buckle, and again on the uppermost tasset of his armour where the decorative motif of the cuirass shows through *[Fig. 26]*. One of the most significant *pentimenti* is Judas' ear which was originally painted two centimetres higher *[Fig. 27]*, while the use of radiographs showed up some minor adjustments to the profile of his face. Even some details of the figure of Christ must have been altered; the hands

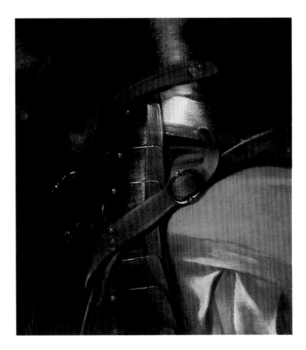

Fig. 26. Detail of *Plate 1*

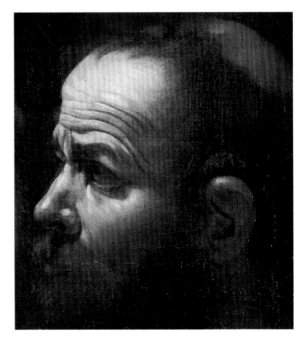

Fig. 27. Detail of *Plate 1*

34

in particular were probably crossed differently as it is clear that the folds of his cloak originally radiated from a central point. Infra-red examination also showed up subtle modifications to the left eyelid and the ear of the presumed self-portrait of the artist, and to the sleeves of the youth on the left *[Fig. 28]*.

Several technical peculiarities, frequently met with in other works by Caravaggio, were also noticed in this painting, such as the irregularly laid ground comprising of a compound rich in impurities. As a result of some harsh cleaning in the past it is now visible in the bright areas of the picture. Also evident is Caravaggio's hasty manner of defining the original composition with rapid brushstrokes which at times are distinguishable even with the naked eye. Another characteristic is the presence of light incisions made on the surface of the painting, visible only in raking light, which marks

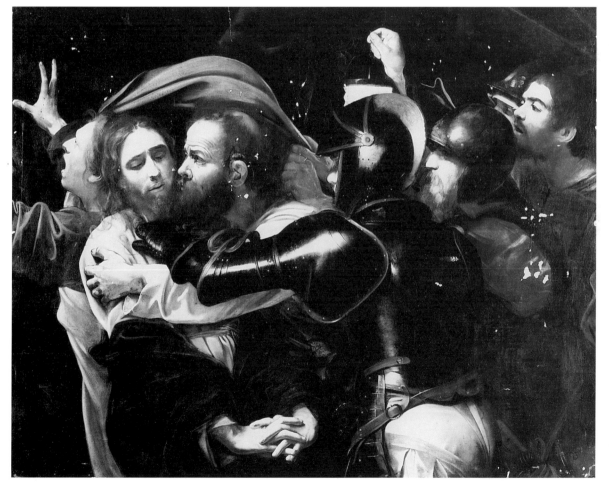

Fig. 28.
Infra-red
photograph of
Plate 1

the uprights of some of the lances in the background. He used a similar technique to simulate a curl on Christ's face, close to the hairline, by scratching a squiggle into the fresh pigment probably with the butt-end of his paintbrush [*Fig. 29*].

Last minute details were added to define or balance the composition better; for example, the small triangular portion of red cloak painted below the throat of the fleeing youth was added with rapid strokes that are smudged at the edges thus indicating that it was a later addition.

Some very close analogies in the use of materials can be made when the Dublin painting is compared with the *St. John the Baptist* in the Pinacoteca Capitolina which was painted by Caravaggio for Ciriaco Mattei about six months earlier. The canvas, a single piece of a heavy hemp with eight by nine threads per square centimetre, is identical in both pictures. The presence of an opaque substance containing calcium was noted during the analyses of the *Taking of Christ*, perhaps chalk added to the pigment as an extender; a similar substance was found in the *St. John the Baptist*.

Fig. 29.
Detail of *Plate 1*

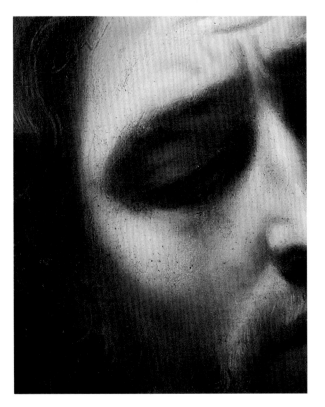

36

With regard to the condition of the painting, it may be deduced from the differing types of retouchings that the picture has undergone at least three earlier restorative interventions, probably accompanied each time by a relining of the canvas. One of these linings caused a shrinking of the surface in some limited areas. Otherwise, the picture is in satisfactory condition, with some damage to Judas' hair, and a few other small abrasions. Analyses have shown that the ground is composed of a brown pigment, heterogeneous and unevenly applied. Several pigments were mixed with it: lead white, red and yellow ochre, umber and large granuli of green earth. On the surface the principal paints used were malachite *[Fig. 30]*, lead tin-yellow, lead white, ochre and black. Christ's blue drapery was painted with azurite over a brown layer of indigo *[Fig. 31]*.

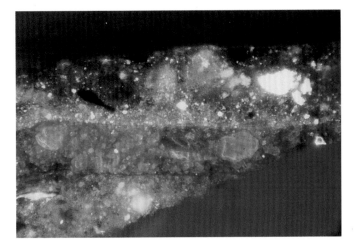

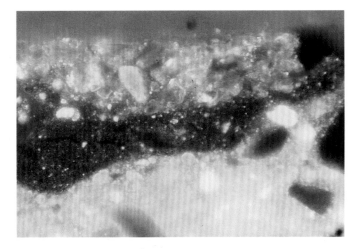

Fig. 30. Cross-section taken from the disciple's arm, far left, of the *Taking of Christ*. Three distinct layers of paint were applied over the ground: a bright green layer of malachite, then a lead-tin yellow paint mixed with malachite, and over this a brown layer made by malachite mixed with bone-black, probably used for the shadows.

Fig. 31. Paint cross-section taken from Christ's drapery illustrating the azurite layer over the dark brown indigo. Beneath is the ground, unevenly applied.

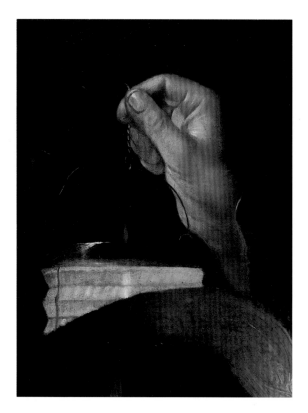

GIUSEPPE CESARI,
Called the "CAVALIER D'ARPINO"
Arpino 1568 - Rome 1640

1. *The Arrest of Christ*
Oil on copper, 56 x 17 cm.
Borghese Gallery, Rome
Inv. no. 356

Born into a family of painters in a village south of Rome, Giuseppe Cesari probably arrived in the Papal City about 1582. He achieved early recognition while employed at a very young age as a frescoist in the Logge of the Vatican, which led to work in the Sala Vecchia degli Svizzeri and the Sala dei Palafrenieri, both in the Vatican. In 1586 he was elected a member of the Congregazione dei Virtuosi del Pantheon and in the following years he was involved in many more commissions for different churches in Rome and also in Naples, where he painted in the Certosa di San Martino. His pictorial style, portraying elegant, elongated and vaguely melancholic figures, emphasising their fluttering robes which were painted with transparent and delicate colours, made him both popular and acclaimed. Regrettably, his tendency to protract his undertakings resulted in some instances in the suspension of work with the consequent loss of trust by his patrons. This was the case with the unfinished decoration of the Contarelli Chapel in San Luigi dei Francesi, later completed by Caravaggio with his images of St. Matthew. At the end of 1599, Cavalier d'Arpino became Prince of the Accademia di San Luca (a position he would hold three times) and in 1601 he obtained the cross of Cavaliere di Cristo from Pope Clement VIII, in recognition of his work in San Giovanni in Laterano.

This small *Arrest of Christ* was painted by Cavalier d'Arpino in the years 1596-97, and in Bellori's opinion it was his best work. The composition is very animated and crowded, with figures moving in different directions (Röttgen, 1973), caught by the shining light of the moon which imparts an unreal atmosphere to the entire scene. In painting it Cavalier d'Arpino may have been influenced by a fresco in the Oratorio del Gonfalone in Rome, probably painted by Marcantonio del Forno in 1575 (Strinati, 1976). As in that earlier work, Cesari chose to describe the moment of the abduction of Christ, after the kiss of Judas, who rapidly disappears into the dark of the night. He also illustrates the episode of St.Peter cutting off the ear of the High Priest's servant Malchus (St. John, 18: 10), and that of the young disciple left naked when seized by the guards (St. Mark, 14: 51- 52). The latter incident, popularised by the circulation of Dürer's engravings of this subject (Cat. no. 2) where it was usually represented in the distant background, was brought forward by Cesari, perhaps inspired by the memory of a well known canvas by Correggio (Röttgen, 1973).

The painting was kept by Cavalier d'Arpino until its confiscation, together with many other pictures and goods, in 1607 by the officers of Pope Paul V. This happened because the artist was found in possession of a small collection of wheel-lock guns, an offence which was severely punishable at the time. Subsequently imprisoned for a while, the artist was obliged to renounce his property in order to obtain a papal pardon and his freedom. His paintings thus ended up in the growing collection of the Pope's

nephew, Cardinal Scipione Borghese. Among those seized were a few early works by Caravaggio, painted just one year after his arrival in Rome, during his short employment in Cavalier d'Arpino's studio. The relationship between the two artists does not seem to have been particularly friendly, but Caravaggio held Giuseppe Cesari in esteem as a painter and some of Cesari's ideas were carefully absorbed by the Lombard painter although not in the case of the *Taking of Christ*. The difference in the conception of the same subject by the two artists is evident, and while one is intent on representing a timeless scene with grace and refinement, the other has created a human drama with powerful expression.

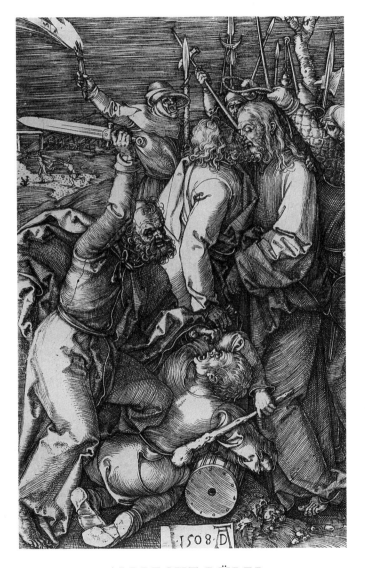

ALBRECHT DÜRER
Nuremberg 1471 - Nuremberg 1528

2. *The Arrest of Christ 1508,* from the *Great Passion* series
Woodcut 11.8 x 7.5 cm
The Trustees of the Chester Beatty Library

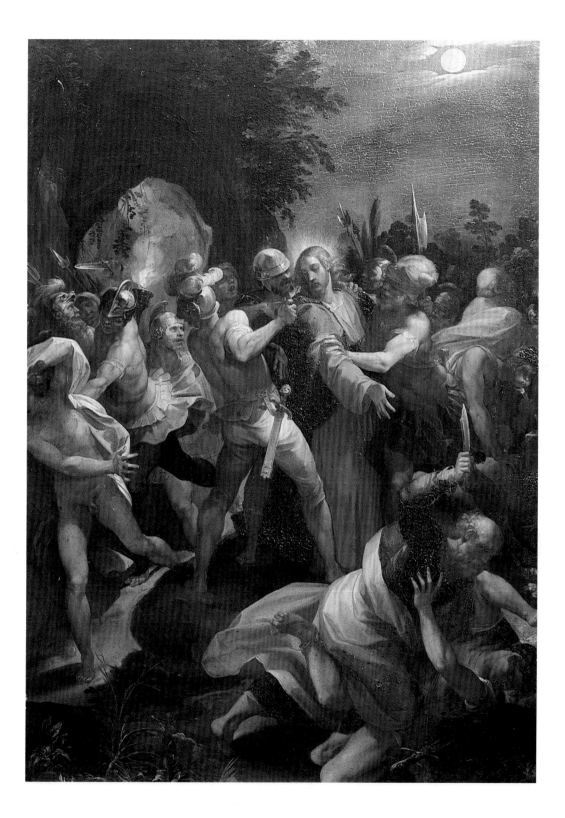

ANTIVEDUTO della GRAMMATICA

Rome 1570/71 - Rome 1626.

3. *Christ Disputing with the Doctors*

Oil on canvas, 139 x 194 cm.

Private Collection, Scotland.

According to Giovanni Pietro Bellori, Caravaggio, some time after his arrival in Rome, found the opportunity to work briefly in the bottega of Antiveduto della Grammatica where he painted *mezze figure,* meaning portraits or half-length images of saints. Indeed, Antiveduto's early reputation was for his portraits, which were good likenesses, as well as copies of illustrious figures from the past. Regrettably, none of his works of this period have yet been identified, and it is only from the second decade of the century, when he himself became 'caravaggesque', that we can properly recognise his artistic personality. The earliest picture known by him is a *St. Cecilia* from a private Spanish collection in Salinas (Rivera, 1980) which was signed and dated 1611. Another *St. Cecilia,* this time with angels, in the National Museum of Lisbon, was possibly painted between 1613 and 1615 (Riedl- Schleier, 1992). Of the same date is this *Christ Disputing with the Doctors,* which was certainly painted before 1614, as it was owned by Ciriaco Mattei (Cappelletti, 1992), who died in that year.

Considering the subject, the composition is more elaborate than his earlier works but in spite of the artist's efforts, it is not fully accomplished. His attempt to characterise the faces of the Jewish theologians individually is, however, skilfully achieved with the use of cool tonalities, confirming his fame as a portraitist. The biographer physician Giulio Mancini writing about Antiveduto said that he was excessive in the pictorial treatment of the hair, and this is more than evident in the adolescent Jesus portrayed here. The accuracy with which each curl is painted, and the shape of his head-dress, recalls (as in other pictures by him), one of the most famous classical sculptures, the Apollo del Belvedere (Riedl- Schleier, 1992). The similiarity of the head of Jesus in this painting with that of the angel playing the lute in the already mentioned Lisbon canvas strongly proves the contemporaneity of the two works.

From the list of paintings found in Cardinal Del Monte's residences at the time of his death, we know that as well as those by Caravaggio he owned many works by Antiveduto and in particular, a picture of the same subject and almost the same size as the one presented here (Frommel, 1971). Knowing the friendship that existed between Cardinal Del Monte and Ciriaco and Giovanni Battista Mattei, it is not surprising that they also shared similar tastes.

Christ Disputing with the Doctors was one of the six paintings sold in January 1802, by the Mattei family to William Hamilton Nisbet. It had been reattributed at the end of the eighteenth century, like most of the others, and in this case it was said to be by 'Caravaggio'. The picture was brought to Biel, East Lothian, where it remained until 1921, when it was sold at auction in Edinburgh. In 1954 the Rev. John Fusco in Cowdenbeath sent a photograph of the painting to Federico Zeri, who first identified it as a work of Antiveduto della Grammatica, and who also recognised its Mattei provenance from a seal found on the back of the canvas during restoration, and correctly understood it to be the same picture referred to as a Caravaggio by M. Vasi in his guide book of 1792. The painting was later published by Roberto Longhi in 1969 and is exhibited here for the first time.

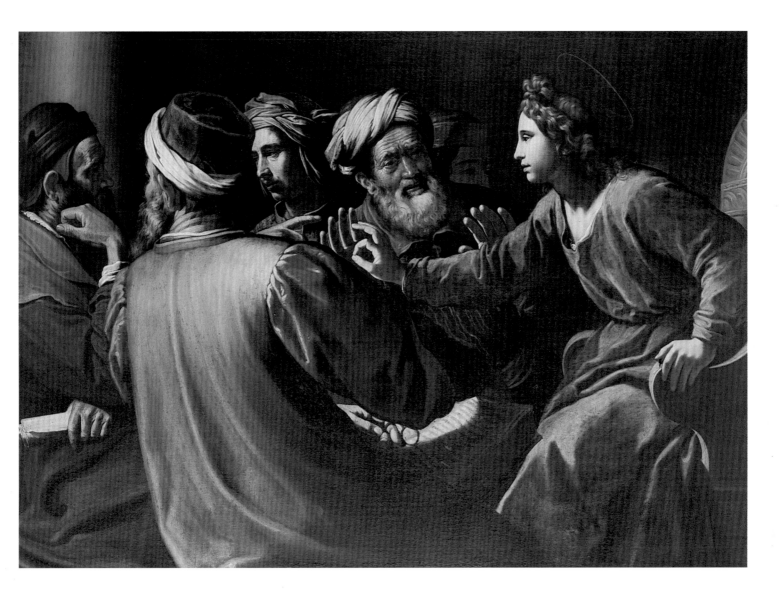

DIRCK VAN BABUREN

Wijk bij Duurstede 1594/1595 - Utrecht 1624

4. *The Arrest of Christ*

Oil on canvas, 139 x 202 cm.

Borghese Gallery, Rome

Inv. no. 28

Born near Utrecht into a family of some distinction (Blankert/Slatkes, 1986), van Baburen is recorded in 1611 as a pupil of Paulus Moreelse. A short time later, perhaps attracted by the fame of Caravaggio, he made his way to Italy, where he arrived sometime before 1615. His first public work in Rome, the decoration of the Pietà Chapel for San Pietro in Montorio of 1617, which he carried out with David de Haen, reveals the strong influence of Caravaggio's *Deposition* in the Chiesa Nuova. From 1619-20 he shared a house with de Haen in *Platea Trinità*, later Piazza di Spagna (Hoogewerff, 1942) and they had the same patrons, the Marquis Vincenzo Giustiniani and the Cardinal Scipione Borghese. Giustiniani owned a *Christ Washing the Disciples' Feet* by van Baburen (Slatkes, 1965) and in his famous letter about the theory of painting, addressed to Dirk van Ameyden, he includes this artist among the painters of the 'eleventh degree', Rubens, Ribera, van Honthorst, and ter Brugghen, that is to say, with those who painted with a live model, and with a good balance of colour and light.

For Cardinal Borghese, van Baburen painted this *Arrest of Christ* in which he appears to have absorbed the innovations of Caravaggio's private religious works. The horizontal format follows the type used by the Lombard master in his composition for Ciriaco Mattei (Benedetti, 1993). Even some details are similar, such as the position of the soldier in the foreground, and the hands of Christ. It is not known if van Baburen had the opportunity to see Caravaggio's original, which at that time was the property of Giovanni Battista Mattei (Panofsky-Sörgel, 1967-68), but it is quite probable. On the other hand it is possible that copies of the painting were circulating in Rome.

Excluding the lost version of this subject painted by Manfredi (Nicolson, 1967), the van Baburen example is certainly closest to the revolutionary composition created by Caravaggio.

Around 1620, Dirk van Baburen returned to Utrecht, where he probably continued his activity in a workshop shared with Hendrick ter Brugghen, until he died prematurely in 1624. A copy of his *Arrest* was recorded in the Mietke Gallery in Vienna, in 1938.

AFTER CARAVAGGIO

5. The Cardsharps

Oil on canvas, 103.5 x 135 cm.

Inscribed on the back: *Antonino Pennisi 1774 / fece in Roma.*

Strokestown Park House, County Roscommon.

In September 1802, seven months after the purchase of six paintings from the Mattei family, including the *Taking of Christ* by Caravaggio, William Hamilton Nisbet requested permission to export three more pictures. Among these was a copy of another Caravaggio, the *Cardsharps*. The famous original, now in the Kimbell Art Museum in Fort Worth (Mahon, 1988) [Fig. 1], was painted by the artist just before he became a guest in Cardinal Del Monte's palace. The Cardinal owned the picture until his death when it was acquired by Cardinal Antonio Barberini (Wolfe, 1985) and by inheritance it passed into the Barberini-Colonna di Sciarra Collection.

The *Cardsharps* quickly became one of the most popular of Caravaggio's paintings and probably the most copied. Soon after the artist's death, some of his followers painted variants of the picture, like that by 'Pensionante del Saraceni' now in the Fogg Art Museum (Rosenberg, 1982). The earliest mention of a copy is 1621 (Bertolotti, 1881), but most were painted in the second half of the eighteenth century. At that time the original painting, still in the Barberini palace, was one of the pictures most admired by British Grand Tourists in Rome. Its popularity considerably increased after the publication of the *"Schola Italica Picturae"* by Gavin Hamilton in 1773, in which it was illustrated in an engraving by Giovanni Volpato. Among the foreign visitors, the Scots seem to have had a particular interest in the painting as is evident from the number of copies still in Scottish collections (Moir, 1976). David Allan painted a copy as well as a version of the *Fortune Teller,* and it is recorded that James Durno possessed a small replica of the *Cardsharps.* We do not know if the copy owned by William Hamilton Nisbet was also the work of a British artist resident in Rome, but because of the lack of precise references in his family inventories, it seems more probable that it was done by an unknown Italian painter.

The Hamilton Nisbet *Cardsharps* was sold, like Caravaggio's *Taking of Christ,* at auction by Dowell's in 1921 in Edinburgh, and the only valid information given in the sale catalogue is the unusual width of the canvas which measured 46 x 71 inches (117 x 180 cm.).

The version exhibited here, from Strokestown Park House, must be considered one of the finest existing eighteenth century copies of the subject. Unfortunately, nothing is known about its provenance, but we must presume that it was in the possession of the Mahon family, the owners of the house, for several generations.

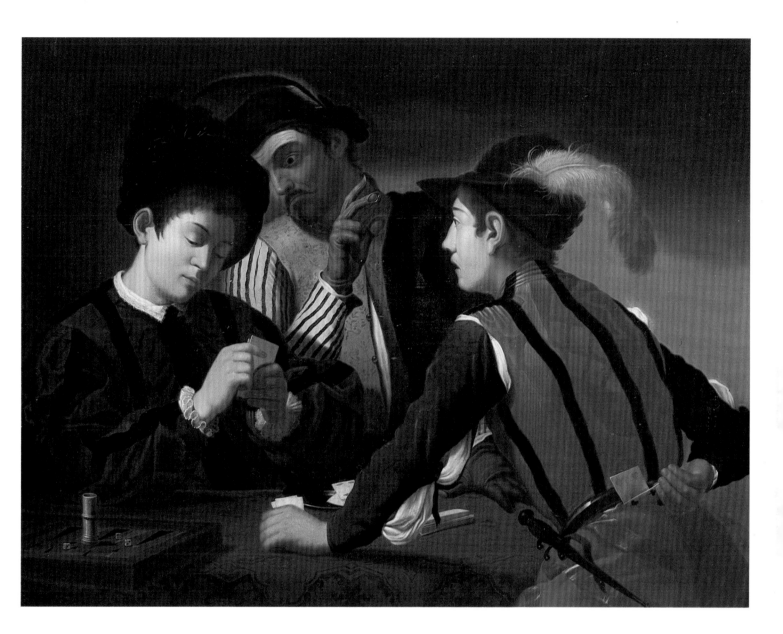

ATTRIBUTED TO FRANCESCO DA PONTE
THE YOUNGER, CALLED BASSANO
Bassano 1549 - Venice 1592

6. *Lazarus at the Feast of Dives*

Oil on canvas, 97.5 x 126 cm.

Sir David Ogilvy's 1968 Trustees

Francesco Bassano spent the first thirty years of his life in the busy workshop of his renowned father Jacopo, in his town of Bassano, then left and settled in Venice in an attempt to achieve his own success, free from his father's tutelage. Notwithstanding the competitive difficulties of artistic life in Venice, Francesco's talent was immediately recognised and the painter soon succeeded in obtaining a number of important public commissions. One of these was the *Assumption of the Virgin* sent to Rome for the high altar of the church of San Luigi dei Francesi, where it was probably admired by Caravaggio. During his last years, Francesco suffered greatly from a mental illness and in 1592 he tragically ended his life by throwing himself out of a window, at the age of forty-three (Ridolfi, 1648).

A much favoured subject, *Lazarus at the Feast of Dives* is a typical example of a canvas painted by Francesco for a private client. The theme is one of Jesus' parables, recorded by St. Luke, but the artist's real intention is to represent people carrying out their daily tasks in a naturalistic manner. The nocturnal ambience and the detailed description of certain objects are characteristic of Francesco's work, but the participation of a less competent hand is also discernible in some areas of the canvas, and probably the work was finished by someone else.

The painting, with its pendant *The Adoration of the Shepherds* in the National Gallery of Scotland (now in Paxton House, near Edinburgh), was among the six pictures purchased by William Hamilton Nisbet in 1802 from the Mattei palace in Rome (Brigstocke, 1972), and it still retains the frame which was commissioned by Hamilton Nisbet for his newly refurbished house at Biel in 1818 (Benedetti, 1993).

AFTER CARAVAGGIO

7. *The Arrest of Christ*

Oil on canvas, 135 x 145 cm.

The Governors of St. Bede's College, Manchester.

This is a previously unrecorded copy, of mediocre quality and probably painted in the middle of the seventeenth century. It demonstrates the vast success achieved by Caravaggio's original, and the wide dissemination of copies. The composition was cut down vertically on both sides more evidently on the right hand side, resulting in the present square format.

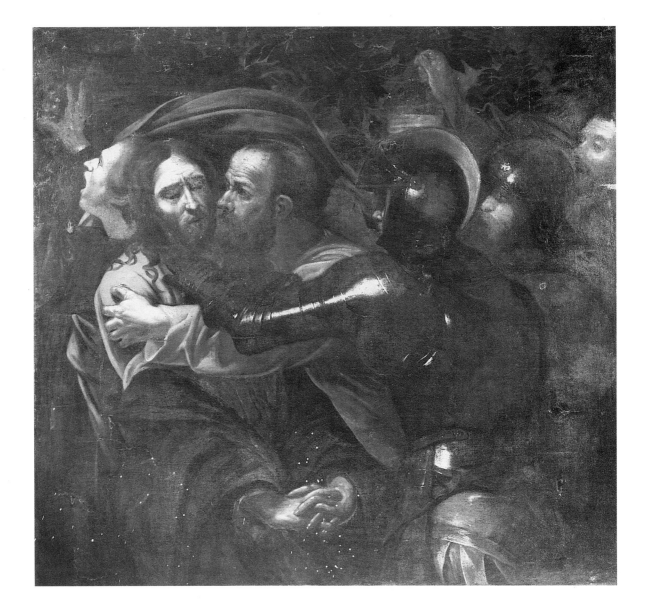

BIBLIOGRAPHY

Aronberg Lavin, M.
1975, *Seventeenth-Century Barberini Documents and Inventories of Art*, New York.

Askew, P.
1990, *Caravaggio's Death of the Virgin*, Princeton.

Baglione, G.
1642, *Le vite de'pittori scultori et architetti, dal Pontificato di Gregorio XIII del 1572; in fino a' tempi di Papa Urbano Ottavo nel 1642*, Rome.

Begni Redona, P.V.
1988, in *Alessandro Bonvicino, Il Moretto*, exhibition catalogue, pp. 112-13, Brescia.

Benedetti, S.
1992, *Caravaggio and his Followers in the National Gallery of Ireland*, exhibition catalogue, Dublin.
1993, "The 'Taking of Christ in the garden' by Caravaggio, a masterpiece rediscovered", *The Burlington Magazine*, CXXXV, 1088, pp. 731-41, 745-46.

Bellori, G. P.
1664, *Nota delli Musei, Librerie, Gallerie ... di Roma*, Rome.
1672, *Le vite de'pittori, scultori e architetti moderni*, Rome. Edited by E. Borea, Turin, 1976.

Bertolotti, A.
1881, *Artisti lombardi a Roma nei secoli XV, XVI e XVII: studi e ricerche negli archivi romani*, 2 vols., Milan.

Black, J.
1992, *The British Abroad. The Grand Tour in the Eighteenth Century*, New York/Stroud.

Blankert A. and Slatkes L.J.
1987, *Holländische Malerei in neuem Licht, Hendrick ter Brugghen und seine Zeitgenossen*, exhibition catalogue, Braunschweig.

Boccia, L.G.
1982, *Le armature di S.Maria delle Grazie...*, Milan.

Bologna, F.
1992, *L'Incredulità del Caravaggio*, Turin.

Brigstocke, H
1993, *Italian and Spanish Paintings in the National Gallery of Scotland*, second edition, Edinburgh.

Calvesi, M.
1990, *Le realtà del Caravaggio*, Turin.

Campbell, M.
1992, *Ecco Roma, European Artists in the Eternal City*, exhibition catalogue, Edinburgh.

Cappelletti, F.
1992, "La committenza di Asdrubale Mattei e la creazione della Galleria nel Palazzo Mattei di Giove a Roma", *Storia dell'Arte*, 76, pp . 256-95.
1993, "The documentary evidence of the early history of Caravaggio's 'Taking of Christ'", *The Burlington Magazine*, CXXXV, 1088, pp. 742-46.

Cappelletti, F., and Testa, L.
1990, "Ricerche documentarie sul 'San Giovanni Battista' dei Musei Capitolini e sul 'San Giovanni Battista' della Galleria Doria Pamphili ", in *Identificazione di un Caravaggio. Nuove tecnologie per una rilettura del 'San Giovanni Battista' di Roma*, Rome.
1990, "I quadri di Caravaggio nella collezione Mattei: I nuovi documenti e i riscontri con le fonti", *Storia dell'Arte*, LXIX, pp. 75 -84.

Celio, G.
1638, *Memoria delli nomi dell'Artefici delle Pitture, che sono in alcune Chiese, Facciate, e Palazzi di Roma,* Naples.

Clark, A.
1967, *Pompeo Batoni,* exhibition catalogue, Lucca.

Christiansen, K.
1986, "Caravaggio and 'l'esempio davanti dal naturale'", *The Art Bulletin,* 68, pp. 421-45.
1988, "Appendix: Technical Report on 'The Cardsharps'", *The Burlington Magazine,* CXXX, 1018, pp. 26-27.

Chacon (Ciaconius), A.
1630, *Vitae et res gestae Pontificum Romanorum, et S.R.E. Cardinalium, 2* vols., Rome.

Cinotti, M.
1983, *Michelangelo Merisi detto il Caravaggio,* in *I Pittori Bergamaschi: Il seicento,* vol. I, pp. 205-641, Bergamo.

Czobor, A.
1957, "'L'Arrestation du Christ' du Caravage", *Bulletin du Musée Hongrois des Beaux-Arts,* X, pp. 26-30.

De Brosses, C.
1973, *Viaggio in Italia, Lettere familiari,* Italian ed. p. 315.

De Moura Sobral, L.
1978, "Una copia del Caravaggio in Bolivia", *Arte y Archeologia,* VI, pp. 175-80.

De Rinaldis, A.
1935-1936, "D'Arpino e Caravaggio," *Bollettino d'arte,* 29, pp. 577-80.

Ford, B.
1974, "The Earl Bishop, An Eccentric and Capricious Patron of the Arts", *Apollo,* 99, pp. 426-34.
1974, "James Byres", *Apollo,* 99, pp. 446-61.

Figgis, N.
1987, "Irish Artists and Society in eighteenth century Rome", *Irish Arts Review,* vol. 4, 4, pp. 28-36.

Friedlaender, W.
1955, *Caravaggio Studies,* Princeton. Revised ed., New York, 1969.

Friz, G.
1974, *La popolazione di Roma dal 1700 al 1900,* Rome.

Frommel, C.L.
1971, "Caravaggios Frühwerk und der Kardinal Francesco Maria del Monte", *Storia dell'Arte,* 9/10, pp. 5-52.
1971, "Caravaggio und seine Modelle", *Castrum Peregrini,* 96, pp. 21-55.

Giustiniani, V.
1620 circa, [1981], "Discorsi sulle arti e sui mestieri," edited by A. Banti, Milan.

Guerrini, L. et al.
1982, *Palazzo Mattei di Giove- Le Antichità,* Rome.

Gregori, M. et al
1985, *The Age of Caravaggio,* exhibition catalogue, New York/Naples.
1992, *Michelangelo Merisi da Caravaggio, Come nascono i Capolavori,* exhibition catalogue, Milan.

Haskell, F.
1963, *Patrons and Painters,* New York.

Haskell, F., and Penny, N.,
1981, *Taste and the Antique: The Lure of Classical Sculpture, 1500- 1900,* New Haven/London.

Hibbard, H.
1983, *Caravaggio,* New York.

Hautecoeur, L.
1910, "La vente de la collection Mattei et la naissance du Musée Pio-Clementin", *Mélanges d'Archeologie et d'Histoire,* pp. 57-75.

Houtzager, M. E., and Meijer, E.
1952, *Caravaggio en de Nederlanden: Catalogus,* exhibition catalogue, Antwerp.

Kirwin, W. C.
1971, "Addendum to Cardinal Francesco Maria Del Monte's Inventory", *Storia dell'Arte,* 9/10, pp. 53-56.

Lasaref, V.
1963, "Una nuova opera del Caravaggio, 'La presa di Cristo all'orto', in *Scritti di Storia dell'Arte in onore di Mario Salmi,* vol. III, Rome, pp. 275-85.

Longhi, R.
1943, "Ultimi studi sul Caravaggio e la sua cerchia", *Proporzioni,* I, pp. 5-63.
1960, "Un originale del Caravaggio a Rouen e il problema delle copie caravaggesche", *Paragone,* XI, 121, pp. 23-36.
1969, "'Giovanni della Voltolina' a Palazzo Mattei", *Paragone,* XX, 233, pp. 59-62.

Lossow, H.
1956, "'La Presa di Cristo', Ein Fragment eines verlorenen Gemäldes des Michelangelo da Caravaggio", *Zeitschrift für Kunstgeschichte,* XX, pp. 206-10.

Mack, R.E.
1974 "Girolamo Muziano and Cesare Nebbia at Orvieto," *The Art Bulletin,* 56/3, September, pp. 410-13.

Malitskaja, X.
1956, "Kartina italjanskoi skoly is Odesskogo Museja", *Iskusstvo,* IV, pp. 67-70.

Mahon, D.
1947, *Studies in Seicento Art and Theory,* London.
1952, "Addenda to Caravaggio", *The Burlington Magazine,* XCIV, 586, pp. 3-22.
1988, "Fresh light on Caravaggio's earliest period: his 'Cardsharps' recovered," *The Burlington Magazine,* CXXX, 1018, pp. 10-25.

Mancini, G.
1620 circa, [1956], *Considerazioni sulla pittura,* 2 vols., by A. Marucchi/ L. Salerno, Rome.

van Mander, C.
1617, [1906], *Das Leben der niederländischen und deutschen Maler des Carel van Mander,* vol. I, translated by H. Floecke, Munich/Leipzig.

Marini, M.
1974, *Io Michelangelo Merisi da Caravaggio,* Rome.
1983, "Equivoci del caravaggismo 2: A) Appunti sulla tecnica del 'naturalismo' seicentesco, tra Caravaggio e 'Manfrediana Methodus'. B) Caravaggio e i suoi 'doppi'. Il problema delle possibili collaborazioni", *Artibus et historiae,* IV, 8, pp. 119-54.
1987, *Caravaggio: Michelangelo Merisi da Caravaggio "pictor praestantissimus",* Rome.

Merlo, G.
1987, in *Dopo Caravaggio, Bartolomeo Manfredi e la Manfrediana methodus,* exhibition catalogue, Milan, pp. 74-75.

Moir, A.
1976, *Caravaggio and his Copyists,* New York.

Nicolson, B.
1967, "Bartolomeo Manfredi," in *Studies in Renaissance and Baroque Art presented to Anthony Blunt,* pp. 108-12, London.

Orbaan, J. A. F.
1920, *Documenti sul Barocco in Roma,* Rome.

Panofsky- Sörgel, G.
1967- 68, "Zur Geschichte des Palazzo Mattei di Giove", *Roemisches Jarbuch für Kunstgeschichte,* XI, pp. 109-88.

Papi, G.
1990, "Note al Grammatica e al suo ambiente", *Paradigma,* 9, pp. 107-27.
1990, "Note in margine alla mostra 'L'arte per i Papi e per i Principi nella campagna romana...'", *Paragone,* 485, pp. 76-81.

Parks, N.R.
1985, "On Caravaggio's 'Dormition of the Virgin' and its setting", *The Burlington Magazine,* CXXVII, 988, pp. 438-48.

Pietrangeli, C.
1983, "The discovery of Classical art in eighteenth-century Rome", *Apollo,* pp. 380-91.

von Ramdohr, F. W. B.
1787, *Ueber Mahlerei und Bildhauerarbeit in Rom fuer Liebhaber des Shoenen in der Kunst,* Leipzig.

Ridolfi, C.
1648, *Delle Maraviglie dell'Arte, overo delle vite degl'illustri pittori veneti e dello Stato,* Venice.

Riedl P. and Schleier E.
1992, "Ein unbekanntes Hochaltarbild Antiveduto della Grammaticas in Todi und weitere Neuzuweisungen", *Pantheon,* 17/18, pp. 61-73.

Rosenberg, P.
1982, *La peinture française du XVII siècle dans les collections américaines,* exhibition catalogue, Paris.

Röttgen, H.
1973, *Il Cavalier d'Arpino,* exhibition catalogue, Rome, Palazzo Venezia.
1974, *Il Caravaggio: Ricerche e interpretazioni,* Rome.
1985, in *The Age of Caravaggio,* exhibition catalogue, New York, The Metropolitan Museum of Art, pp. 129-35.

Salerno, L.
1960, "The Picture Gallery of Vincenzo Giustiniani", *The Burlington Magazine,* CII, pp. 21-27, 93-104, 135-48.

Schneider, T.M.
1987, "La 'maniera' e il processo pittorico del Caravaggio", in *L'Ultimo Caravaggio,* pp. 117-38.

Skinner, B.
1966, *Scots in Italy in the 18th Century,* Edinburgh.

Spear, R.
1971, *Caravaggio and His Followers,* exhibition catalogue, Cleveland.

Spezzaferro, L.
1974, "The Documentary Findings: Ottavio Costa as a Patron of Caravaggio, *The Burlington Magazine,* CXVI, pp. 579-86.

Strinati, C.
1976, "Marcantonio Del Forno nell'Oratorio del Gonfalone a Roma," *Antichità Viva,* 3.
1989, "Caravaggio nel 1601", in *Caravaggio. Nuove Riflessioni,* Quaderni di Palazzo Venezia, 6, pp. 162-78.

Titi, F.
1763, *Descrizione delle Pitture, Sculture e Architetture esposte al pubblico in Roma,* 2 vols, Rome.

Treffers, B.
1989, "Dogma, esegesi et pittura: Caravaggio nella Cappella Contarelli in San Luigi dei Francesi", *Storia dell'Arte,* 67, p. 246.

Vasi, G. and Vasi, M.
1786, *Itinéraire instructif de Rome,* 2 vols., Rome.

Venturi, F.
1973, "1764-1767: Roma negli anni della fame", *Rivista storica italiana,* III, pp. 514-43.

Wiemers, M.
1986, "Caravaggio 'Amor Vincitore' im Urteil eines Romfahrers um 1650" *Pantheon,* 44, pp. 59-61.

Wolfe, K.
1985, "Caravaggio: another 'Lute player', *The Burlington Magazine,* CXXVII, 988, pp. 450-52.

ADDITIONAL BIBLIOGRAPHY

Algeri, G.
1985, "Le incisioni della 'Galleria Giustiniana.' " *Xenia*, 9, pp.71-99.

Benedetti, S.
1995, "Caravaggio's 'Taking of Christ'" Letter/Addendum, *The Burlington Magazine*, CXXXVII, 1102, pp. 37-8.

1995, "Gli acquisti romani di William Hamilton Nisbet", *Paragone*, XLVI, 547, pp. 69-86.

1995, "Presa di Cristo nell'orto", in *Caravaggio e la Collezione Mattei*, exhibition catalogue, pp. 124-7.

1999, "Classical and Religious Influences in Caravaggio's Painting", in *Saints & Sinners: Caravaggio & the Baroque Image*, exhibition catalogue, ed. F.Mormando, pp. 208-35, Boston.

Bober P.P. and Rubistein R.
1986, *Renaissance Artists and Antique Sculpture*, London and Oxford.

Bona Castellotti, M.
1998, *Il paradosso di Caravaggio*, Milano.

Cappelletti F. and Testa L.
1994, *Il trattenimento di Virtuosi: Le collezioni secentesche di quadri nei Palazzi Mattei di Roma*, Rome.

Christiansen, K.
1996 (1992), "Thoughts on the Lombard training of Caravaggio", in *Come dipingeva il Caravaggio*, Atti della giornata di Studi, ed. M.Gregori, pp.7-28, Milan.

Danesi Squarzina, S.
1997, "The Collections of Cardinal Benedetto Giustiniani: I", *The Burlington Magazine*, CXXXIX, 1136, pp.766-91.

1998, "The Collections of Cardinal Benedetto Giustiniani: II", *The Burlington Magazine*, CXXXX, 1139, pp.102-14.

Gallo, M.
1995, "Il 'Sacrificio di Isacco' di Caravaggio agli Uffizi come meccanica visiva della satisfactio", in *Michelangelo Merisi da Caravaggio:La vita e le opere attraverso i documenti*. Atti del Convegno Internazionale di Studi, ed. S. Macioce, 331-60, Rome.

Herrmann Fiore, K.
1995, "Caravaggio's 'Taking of Christ' and Dürer's woodcut of 1509", *The Burlington Magazine*, CXXXVII, 1102, pp.24-27.

Langdon, H.
1998, *Caravaggio: A Life*, London.

Ragusa I. and Green R.B., tr. & ed.
1961, *Meditations on the Life of Christ: An Illustrated Manuscript of the Fourteenth Century*, Princeton, NJ.

Schröter, E.
1995, "Caravaggio und die Gemäldesammlung der Familie Mattei", *Pantheon*, 53, pp. 62-87.

Strinati, C.
1995, "La mano di ferro", in *Caravaggio e la collezione Mattei*, exhibition catalogue, pp.11-6, Milan.

Treffers, B.
1988, "Il San Francesco Hartford del caravaggio e la spiritualità francescana alla fine del XVI secolo", *"Mitteilungen des Kunsthinstorichen Institutes in Florenz*, pp.145-71.

1995, "Immagine e predicazione nel Caravaggio", in *Michelangelo Merisi da Caravaggio:La vita e le opere attraverso i documenti*. Atti del Convegno Internazionale di Studi, ed. S. Macioce, 270-88, Rome.

Wazbinski, Z.
1994, *Il Cardinal Francesco Maria Del Monte, 1549-1626*, 2 vols. , Florence

PHOTOGRAPHIC
ACKNOWLEDGEMENTS

© The National Gallery of Ireland: Plate 1, Figs. 3, 4 , 11, 15, 17, 22, 23, 26, 27, 28, 29, 30, 31, Cat. no. 3

© Kimbell Art Museum, Fort Worth: Fig. 1

© Istituto Centrale del Restauro: Figs. 2, 7

© Photo Giraudon: Fig. 5

© National Gallery, London: Plate 2

© Cappelletti/Testa: Fig. 6

© Pinacoteca Capitolina: Plate 3

© Gemäldegalerie SMPK, Berlin-Dahlem: Fig. 8

© Bildarchiv Preussischer Kulturbesitz, Berlin: Plate 4

© Author: Figs. 9, 19

© National Portrait Gallery of Scotland: Fig. 10

© Sir David Ogilvy's 1968 Trustees: Figs. 12, 13, Cat. no. 6

© Archivio di Stato di Roma: Fig. 14

© Réunion des Musées Nationaux, Paris: Fig. 16

© Pinacoteca Ambrosiana, Milan: Fig. 18

© Walker Art Gallery, Liverpool: Fig. 20

© Museo Diocesano, Mantua: Fig. 21

© Museum of Eastern and Western Art, Odessa: Fig. 25

© Witt Library, London: Fig. 24

© Istituto Centrale per il Catalogo e la Documentazione, Rome: Cat. nos. 1, 4

© Chester Beatty Library, Dublin: Cat. no. 2

© Strokestown Park House, Co. Roscommon: Cat. no. 5

© St. Bede's College, Manchester: Cat. no. 7